IMAGES
of America

BRIDGEPORT
FIREFIGHTERS

Trucks 1 and 2 are shown after successful trials of the new C.J. Cross motorized tractors on July 20, 1914. The two Hayes–American LaFrance trucks had 75-foot-long, spring-loaded, wood aerial ladders. Norman Street's Truck 1, at left, was purchased in 1892, while Middle Street's Truck 2 was purchased in 1908. Both were originally horse-drawn. The motorized tractors extended the lives of the ladder trucks into the 1930s. Note the tillermen, sitting to the rear of the trucks. Tillermen steered the rear wheels, which allowed the long fire trucks to negotiate the tight, crowded Bridgeport streets.

IMAGES
of America

BRIDGEPORT FIREFIGHTERS

Bridgeport Firefighters' Historical Society

Book Committee Chairman:
Robert Novak Jr.

Co-chairs:
David Acanfora, Audrey Blair, Tom Connor,
Peter Oliva, John Sheehan

ARCADIA

Copyright © 2000 by The Bridgeport Firefighters' Historical Society.
ISBN 0-7385-0492-0

First printed in 2000.
Reprinted in 2001.

Published by Arcadia Publishing,
an imprint of Tempus Publishing, Inc.
2A Cumberland Street
Charleston, SC 29401

Printed in Great Britain.

Library of Congress Catalog Card Number: 00-107744

For all general information contact Arcadia Publishing at:
Telephone 843-853-2070
Fax 843-853-0044
E-Mail sales@arcadiapublishing.com

For customer service and orders:
Toll-Free 1-888-313-2665

Visit us on the internet at http://www.arcadiapublishing.com

CONTENTS

Introduction		7
1.	Founding Bridgeport and Its Fire Service	9
2.	The Volunteers	15
3.	The Career Fire Department	27
4.	New Century, New Ideas	35
5.	Protecting the Industrial Capital	53
6.	The Hayden Years	75
7.	Signal 29, Signal 29	91
8.	The Photography of Joseph Lamb	103
9.	Postscript	117

When I am called to duty, God
Where ever flames may rage,
Give me the strength to save some life
Whatever be its age.
Help me embrace a little child
Before it is too late
Or save an older person from
The horror of that fate.
Enable me to be alert and hear the weakest shout
And quickly and efficiently
To put the fire out
I want to fill my calling and
To give the best in me,
To guard my every neighbor and
Protect his property.
And if according to my fate
I am to lose my life
Please bless with your protecting hand
My children and my wife.

—Author unknown

INTRODUCTION

On May 20, 1997, about a dozen of Bridgeport's firefighters gathered at fire headquarters on 30 Congress Street. Proud of their department's history and heritage, and eager to learn more, they founded the Bridgeport Firefighters' Historical Society. An ambitious list of goals was drawn that evening, some of which have since been met, while others await completion. A major goal was to write a book about the Bridgeport Fire Department and its firefighters.

It is therefore with great satisfaction and pleasure that the historical society releases *Images of America: Bridgeport Firefighters*. Filled with close to 200 photographs, this book chronicles the history of Bridgeport's firefighters from the purchase of the first fire engine in 1796 to the conclusion of Sylvester Jennings's term as Bridgeport's fire chief in 1971. We chose that year as the cutoff date because of the book's limited space and because we opted to cover the various eras illustrated in the book as thoroughly as possible; we could not satisfactorily cover the dynamic period after that time. Historical eras and fire chiefs' terms were employed in determining where a chapter ends and where another begins. The final chapter is intended to tie loose ends together and to bring closure to themes that concluded after Chief Jennings.

Why did we write this book? As firefighters and historical society members, we are exceptionally proud of our history and heritage. The Bridgeport firefighters' past stretches beyond that of many Connecticut towns. We uncovered many surprises in conducting our research, such as the fact that the city's first bid for independence from the Town of Stratford was the result of the desire to organize a local fire department. Although this book covers only up to 1971, the pride extends beyond that to the present day.

This book reflects that Bridgeport's pre-1971 fire service had only two minorities throughout its history. Today's fire department is much more diversified, employing African American, Hispanic, and female firefighters. Another major change is the modern apparatus, equipment, gear, and firehouses the department currently deploys. And although the city is no longer burning as it was in the 1970s and 1980s, new firefighters are trained at higher levels than they were before. Despite all these positive changes, the historical society feels it is important for us to remember where we and the community we serve have come from in order to help understand who we are today. Perhaps this knowledge will give insight to decisions that will affect who we are tomorrow.

Thanks must be extended to the Bridgeport Firefighters' Historical Society Book Committee members: David Acanfora, Azora "Audrey" Blair, Pres. Thomas Connor, Peter Oliva, and John Sheehan. Others who assisted in research or editing included Joseph DiCarlo, George Dragone,

Manuel Firpi, Terrance O'Connell, and Lorenzo Pittman. Much gratitude must also be extended to Mary Witkowski of the Bridgeport Public Library, Historical Collections.

Finally, we would be remiss if we did not specially thank Arthur Selleck of the Connecticut Firemen's Historical Society. Art personally witnessed much of the 20th-century history of Bridgeport and its firefighters, photographed much of it, and kept meticulous records. Without his lifetime knowledge of the fire department and his willingness to share such with the Bridgeport Firefighters' Historical Society much the material in these pages could never have been included.

Uncredited photographs are the property of the historical society. Known sources of photographs taken, developed, or donated in this book include the Baldwin Collection, the Bridgeport Public Library's Historical Collections, the A.W. Burritt Company, the Connecticut Firemen's Historical Society, George Dragone, Frank DeCerbo Jr., Glenn Duda, Gratt Pharmacy, Joseph Lamb, Loring Photographers, Mattatuck Museum of Waterbury, Greg McDermott, Peter Oliva, Seeley Photographers, Arthur Selleck, and Lou Tibor. A number of photographs, including the one on the cover, come from longtime Bridgeport photographers Corbit Studios.

The historical society would like to thank James Eastwood, Kenneth Fortes, Kathryn Novak, and Ismael Pomales for the donation of computer equipment and the technical expertise necessary for the writing of this book. Lastly, we would like to thank Bridgeport Fire Chief Michael Maglione for providing the Bridgeport Firefighters' Historical Society Book Committee a secure space while this book was being written.

Additional sources of information include newspaper articles from the *Bridgeport Post*, the *Bridgeport Herald*, and the *Bridgeport Star*, as well as *Fire Engineering* magazine. Book sources include *The History of the Old Town of Stratford and the City of Bridgeport* by Samuel Orcutt (1886); *The "Standard's" History of Bridgeport* by the Bridgeport Standard (1897); *The History of Bridgeport and Vicinity* by George C. Waldo (1917), and *The Story of Bridgeport* by Elsie Nicholas Danenberg (1936). The reports of the National Board of Fire Underwriters on the City of Bridgeport from 1904 and 1954 were referred to extensively, as were various pamphlets and literature released over the years from the Bridgeport Fire Department and related organizations. A major source of information was Lennie Grimaldi's book *Only in Bridgeport: An Illustrated History of the Park City* (1999), a must-read for anyone seeking up-to-date information on Bridgeport's unique past.

Active and retired Bridgeport firefighters, their families and friends, firefighters from other departments, interested citizens, and others all compose the growing membership of the Bridgeport Firefighters' Historical Society today. More than 150 individuals have joined since 1997. It is our most sincere hope that this book, a milestone in our short history, represents only the first of our lasting accomplishments. Although the city continues to change with the times, it is highly improbable that there will not be a need for the emergency services provided by the Bridgeport Fire Department or its firefighters in the near or distant future. It is our wish that present and future firefighters will remember their profession's past through reading the nine chapters in this book. Hopefully, some will continue the research, so future publications can expand upon what is written here and add new chapters to the history of Bridgeport's firefighters.

<div align="right">

—Robert Novak Jr.
Bridgeport Firefighter and Committee Chairman
Bridgeport Fire Headquarters
July 19, 2000
bptfirehistory@juno.com

</div>

One
FOUNDING BRIDGEPORT AND ITS FIRE SERVICE

By 1795, what is now Bridgeport centered around the agricultural village of Stratfield (above), at Park and North Avenues, and the seagoing village of Newfield, at State and Main Streets. Newfield was also a business center, boasting 200 in tightly packed, clapboard houses, as well as churches, a schoolhouse, a public ferry, and a bridge that spanned the river. Both villages were part of the town of Stratford.

Wary of the village's vulnerability to fire, Newfield residents circulated a subscription among themselves in 1796. Read before the Connecticut General Assembly in May 1797, it stated, "We . . . promise to pay the sums put to our . . . committee appointed by the people of this Port for the purpose of purchasing a fire engine, buckets, etc." It continued, "the village of Newfield is thickly settled and greatly exposed to the ravages of fire; and that the inhabitants at great expense provided a fire engine with necessary apparatus." Forming a fire company was no trivial matter, as members were excused from performing mandatory militia duty required of most Connecticut adult males. Manually pumped, water was provided by dumping buckets of water into a tublike tank, explaining why these machines were called "hand tubs." Newfield was the fourth town in Connecticut to apply for a fire company. The petition was granted in October 1797. Unfortunately, it was later discovered that since Newfield was not an official entity, there could be no exemption from military service. By the time this 1824 map was drawn, Newfield had grown to 1,210 people.

The Connecticut General Assembly drafted a 1798 resolution making Newfield a "corporation" within Stratford, which allowed 12 from its fire company exemption from militia duty. The firemen were expected to devote their energies to maintaining the fire equipment and training. Initial guidelines for the fire company and related issues were set at a series of meetings at the brick Newfield schoolhouse. Now called McLevy Hall, the Fairfield County Courthouse was built on the schoolhouse site in 1854.

Newfield enforced a strict set of fire codes. Three classes of buildings were established, determining if one, two, or three "good leathern buckets," such as the one at right, were required for immediate use. All males between 14 to 60 years old were part of the bucket brigade and were expected to drill in passing buckets from a water source to the hand tub every first Sunday of the warm months. (Arthur Selleck.)

11

The Borough of Bridgeport succeeded the Corporation of Newfield on October 20, 1800. With the borough came additional territory, population, and responsibility. It was governed by a warden and six burgesses. Much of the borough's meetings and resources were occupied by "preserving the Borough from injury by Fire, and . . . regulating the fire company." St. John's Episcopal church, later a Baptist church, was built on Broad and Cannon Streets a year later.

Bridgeport's first recorded fire destroyed Lemuel Hubbell's cabinet shop in 1808. A serious fire broke out at a tailor shop on 60 State Street (now a bus terminal) on February 5, 1815, threatening the entire block. Several bystanders were burned when gunpowder stored next-door exploded. Four days later, a movement began to form another fire company, resulting in the establishment of Fire Engine Company 2.

Where Fire Engine Company 1 was located until 1811 is unknown. History records that it was moved that year to the public slip at the foot of Wall Street on the east side of Water Street. The location is shown here before 1900; a block below the old Stratford Avenue Bridge is in the middle of the picture. Note that the railroad tracks, which parallel Water Street, have not yet been elevated. The fire engine remained there until 1821, long before this picture was taken. The engine's new location was south of this scene, at the corner of Water and Union Streets. Already fronted by docks in the early 1800s, Water Street was Bridgeport's main commercial thoroughfare until 1845. Note the Congress Street Bridge farther upstream in this picture. The East Side's huge Frank Miller Lumber Company is visible above the right side of the Stratford Avenue Bridge. The Town of Bridgeport, combining old Newfield and Stratfield, independent of Stratford, was incorporated in 1821. The semiautonomous borough continued to administer the downtown. (Arthur Selleck.)

Another serious fire consumed six dwellings and stores between Bank and State Streets (seen here in 1891) in the spring of 1828. In response, a hook and ladder company was formed and was charged with rescuing victims, salvaging goods, and pulling down exposed structures to stop a fire's spread. Initially equipped with six ladders, six hooks, two axes, and rope, a carriage was purchased later that year. The position of "chief engineer," in charge of all companies at a fire, was also instituted that year. (Bridgeport Public Library.)

A fire on Main and Wall Streets (seen here in 2000) destroyed eight houses and a store on November 21, 1833, resulting in Fire Engine Company 3 being formed in 1834. Purchased by the Borough, No. 3 was housed in a Water Street storeroom. The engine relied upon a suction pump that drew water from public wells and other sources, eliminating the need for a bucket brigade to supply it. Although the brigade lingered until 1849, the appearance of No. 3 was the beginning of its end.

Two
THE VOLUNTEERS

Governed by a mayor and common council and encompassing additional territory, the borough became the City of Bridgeport in 1836. It was broken into four wards, each appointing its own fire warden and inspector. Residents paid a special tax releasing them from having to maintain leather buckets. The money raised from this tax, collected until the 1850s, was used to purchase equipment for the fire department. This harbor scene was drawn in 1837.

The destruction of a Water Street grocery store on March 30, 1839, prompted the usual call for fire department improvement. After some consideration by a committee of the Bridgeport Common Council, a new suction pump engine was purchased for No. 2. The old No. 2 engine was moved to Court Street, between the South Congregational and Episcopal churches, where it became Phoenix Fire Company No. 4. The location appears to the right of the two in foreground of this 1837 view of Broad Street's "Church Row."

In 1843, as a result of litigation growing from non-payment of bonds as a result of the city subsidizing the Housatonic Railroad's terminus in Bridgeport, the property of the fire department was attached to several lawsuits. To avoid losing it, the City of Bridgeport actually sold the fire department to the outlying Town of Bridgeport, which then leased the equipment back to the City for $75 per year. This arrangement continued until the litigation was settled in February 1845. (Bridgeport Public Library.)

THE BURNED DISTRICT OF BRIDGEPORT IN 1845.

On the bitterly cold early morning of December 12, 1845, a large wooden Bank Street oyster saloon and boardinghouse (marked A on the map) caught fire. Although the fire department was quick on the scene, the wind, cold weather, and low tide ensured the fire's spread into Bridgeport's oldest buildings on Bank, State, and Water Streets (the shaded area). In many cases, the contents of homes and stores were removed from doomed buildings only to be consumed by flames in the street. The fire was checked at about 4 a.m. (as it headed for Wall Street) when Daniel Hatch's building (marked Y) was pulled down before the fire reached it and the rising tide allowed the engines to stop the fire at building V, near a dock. Forty-nine buildings were destroyed, 40 families were homeless, and the business center was decimated. The fire forever changed downtown, as many Water Street businesses relocated to unaffected Main Street. From that time forward, Main Street was the principal downtown thoroughfare. Another consequence of the fire was the reorganization of the Bridgeport Fire Department in 1848.

Results of the 1848 reorganization included the purchase of a Smith "piano box" engine. Pictured here c. 1915, the engine arrived in early 1849 and was named Excelsior No. 5. The Pacific Engine Company was organized to staff it. Shortly after Excelsior's arrival, a "fire bug" descended upon Bridgeport. Many bad fires between 1849 and 1861 tested the mettle of the new equipment. In reaction to the arson wave, the city disbanded Nos. 1, 3, and 4 in 1849, disposing of their old engines. At that time, No. 1 was still using the 1796 hand pump. A new hand engine similar to Excelsior was purchased in 1850 and was christened Empire No. 4 after its company. The fire engines were city property, and the various volunteer fire companies had to renew their privilege to operate them on an annual basis. Thus, a large number of fire companies with different names and numbers were organized and disbanded in the mid-19th century. Politics were no doubt a major factor in determining which fire companies were renewed. (Arthur Selleck.)

The Bridgeport Water Company laid the first fire hydrants in the city in 1854. The Bridgeport Hydraulic Company took over in 1857. Although one "hose company" was maintained before the hydrants' arrival, they became more important afterwards. Two more hose carts were bought in 1855, and companies formed around them. The cart of one such company, Broad Street's Americus Hose Company 6, appears here across from today's Bridgeport Library.

One of Bridgeport's grandest 19th-century houses belonged to entertainer and mayor P.T. Barnum. This first mansion of his, Iranistan, was located in the area of Fairfield and Iranistan Avenues. The exterior of the house was heavily influenced by Persian and Middle Eastern styles. The inside was no less spectacular, including a grand dining room, a ballroom, and a spacious library. Fire bedeviled Bridgeport's most famous 19th-century resident his entire life. Iranistan burned down on December 17, 1857.

Under the auspices of Mayor Daniel H. Sterling, the Bridgeport Common Council appointed a committee to study the feasibility of purchasing a steam-powered fire engine in the spring of 1863. Producing a favorable recommendation, the committee went one step further that summer, stating that although a paid fire department would cost $1,219 more than the current volunteer system, the benefits in terms of security and safety would make up the difference. A large Amoskeag first-class steam-pumped fire engine was ordered with a hose wagon. A new engine house was constructed on John Street for the Amoskeag. These developments produced an immediate backlash from the volunteers, many of whom were politically powerful with many supporters. They recognized that the horse-drawn, steam-pumped engine would require a much smaller crew. Duties such as keeping a head of steam in the pump's boilers and feeding the horses would require round-the-clock maintenance, which would no doubt lead to a career fire department. One of the first casualties of this bitter conflict was Mayor Sterling, who lost his bid for reelection.

The new steamer, named D.H. Sterling No. 1, arrived in January 1864. Its appearance on city streets often elicited hoots and catcalls from volunteers and their supporters. Shortly after its arrival, the new steamer was given a trial on Broad Street, near the Old North Church (drawn here, built in 1850). The Pacific Engine Company's Excelsior No. 5 was pitted against it, in order to compare the steamer's effectiveness against a hand-drawn engine. Naturally, the volunteers saw this as a challenge to be won and turned out in force. The first test saw Excelsior throw a stream of water 20 feet higher into the air than Sterling. To the volunteers' dismay, Sterling responded by combining four streams into one, shooting clear over the church's steeple. The next test saw both engines placed near Broad and Cannon Streets, to see which could throw water farther on a level surface. Sterling clearly bested Excelsior; its stream crossed State Street to the rear of the South Church building and water seeped into the quarters of Americus Hose Company 6.

D.H. Sterling was not yet in service when a barn burned on Washington Avenue on February 5, 1864, during which Empire No. 4 made its last appearance; it was disbanded shortly after. Two weeks later, Sterling extinguished a bad fire affecting two stores at 19–21 Wall Street. A company was formed around the steamer at its John Street firehouse (left), the words "D.H. Sterling" emblazoned over the center door. Some members received minimal compensation from the Bridgeport Common Council.

Despite a growing sentiment by many segments of the public, particularly the merchants, the political power of the volunteers was strong enough to vote many of Sterling's supporters out of office in the 1864 municipal elections. The new common council voted to look into trading Sterling for two smaller steamers, which would be assigned to two volunteer companies. Here, the volunteer hose cart from Milford's Arctic Engine Company parades at Washington Park in the East Side. Bridgeport's Fountain No. 3 and Americus No. 6 were very similar.

The previous Bridgeport Common Council had already purchased two additional steamers for the volunteers. Arriving in May 1865, the first, named Protector No. 2, was an Amoskeag third-class steamer. Class was determined by pumping capacity; lower meant better. Protector No. 2 was assigned to a fire company of the same name, located in a new engine house on Crescent Place across the Pequonnock River in East Bridgeport. A police lockup was located in the basement.

Steamers drew water from hydrants or ponds and forced it through hoses with the pressure from its steam boilers. However, they were incapable of carrying their own hose, which was why they were provided with hose carts. Companies like Protector were often outfitted with hose reels, sometimes called jumpers, one of which is pictured here. Although the reels were efficient, they gradually changed over to hose wagons after the career fire department was formed.

In June 1865, the Bridgeport Common Council ordered to replace Sterling with two smaller hand-drawn steamers. However, providence intervened on June 23, 1865, when a large fire broke out at the F. Wood and Company carriage factory on the corner of Broad and Cannon Streets, shown here in 2000. It appeared Bridgeport was in for another destructive conflagration when Sterling arrived. An 1898 account reads, "It was a struggle between the steamer and flames for supremacy, and it was a gallant fight. Four streams of water were brought to bear upon the fire, and inch by inch the ground was fought over to drive the flames back. Thousands of friends and opponents of the steamer witnessed the struggle. [Sterling's] Engineer Duncomb comprehended the fact that the fate of the D.H. Sterling depended on the result For hours she stood at the hydrant, thumping and puffing as her pumps were straining to force the hogsheads of water that were being poured upon the fire each minute. It was a gallant fight for supremacy, and the steamer won." (Robert Novak.)

Opposition to the Sterling continued, but the carriage factory fire dealt it a fatal blow. The steamer exchange was canceled, and a council friendlier to Sterling was placed in office at the following election. The second new engine purchased by the previous council, an Amoskeag second-class steamer, arrived in August 1865 and was assigned to the Pacific Engine Company's old firehouse on the corner of Main and Golden Hill Streets. It was named Excelsior No. 5, after the Pacific's gallant hand-pumped engine of the same name. The company was so named because many members were from the Pacific Iron Works, which was on nearby Housatonic Avenue. Unlike the other volunteer fire companies, the Pacific continued as the Iron Works Fire Brigade even after they were dropped from the city rolls. It also continued as a social organization after the factory closed. This picture of the Pacific was taken at Bull's Head Tavern, c. 1890, with a Jeffers steamer, probably undergoing refurbishment at Pacific Iron Works.

After the Pacific withdrew from active service, Sen. Philo Barnum, brother of P.T. Barnum, purchased the old Excelsior hand pump. It wound up protecting an iron foundry in Lyme. In 1903, the year this picture was taken, the Pacific purchased its piece of history and returned it to Bridgeport as a centerpiece. The engine was refurbished and taken to a number of events, musters, and meets in and out of the city.

Nicknamed "the Red Shirts," the Pacific enjoyed several revivals in the 20th century; many prominent Bridgeporters donned the distinctive uniform over the years. Operating out of their clubhouse on 1673 Main Street, the members were active past 1940. Unfortunately, the whereabouts of the Excelsior hand pump are unknown to the Bridgeport Firefighters' Historical Society. Members of the Pacific pose here in 1911.

Three
THE CAREER FIRE DEPARTMENT

A new city charter in 1869 instituted a board of fire commissioners. With a population of more than 19,800 and the fire department's increasing reliance upon horse-drawn steamers that required round-the-clock maintenance, a citizens' petition for a paid fire department was almost unanimously accepted in May 1871. The department began operations on June 1, 1871, with a force of 60 men. The steamers became Engines 1, 2, and 5. The old ladder truck, named Rescue, became Hook and Ladder Company 4.

Having outgrown the Pacific's old Main and Golden Hill Street quarters, a new firehouse was built for Engine 5 at 268 Middle Street in 1876. The old Engine 5 quarters were so small was the engine had to attach its hose cart to the rear of its steamer; the fire house was too small for a cart with its own horse. The new building also served as Bridgeport fire headquarters, as well as the control center for the fire alarm system. For a time after moving to Middle Street, Engine 5's steamer also pulled a cart equipped with soda-acid chemical tanks, which could produce a quick, though limited, stream of water. A blacksmith shop was located next door. Although the fire department had been staffed by career firefighters for five years when this station was built, the city relied heavily throughout the 19th century upon "callmen." Callmen worked other jobs and often responded to their assigned stations on bicycles when summoned by the huge firebells. Appointed in 1869, Charles A. Gerdineir had the distinction of being the last volunteer and first career-era chief engineer.

Also assigned with Engine 5 in its new Middle Street quarters was a much needed hook and ladder truck to replace Rescue. The City of Bridgeport No. 1 was the first truck requiring a tillerman to steer the rear wheels of the long truck through city streets. To justify his position, the tillerman also had to act as the department blacksmith.

Bridgeport's deadliest fire of the 19th century occurred on June 7, 1877, at Glover Sanford and Sons' hat factory on Crescent Avenue. The hydrant supply proved inadequate, forcing steamers to get water from a nearby pond. Eleven bystanders who were trying to save a safe were killed after a wall collapsed. The poor water supply, pressure, and fire department manpower earned Bridgeport harsh criticism in New York and New Haven newspapers. St. Cyril and Methodius Slovak Catholic Church would later be built at that location. (Robert Novak.)

William Jeffers and Company built hand-pumped engines in Pawtucket, Rhode Island, before it began manufacturing steamers in 1861. The company completed 63 steamers before P.S. Skidmore bought and moved it to Bridgeport. The actual manufacturing was performed by Pacific Iron Works. Only eight steamers were manufactured in Bridgeport before the company folded in 1878; it was a victim of intense competition. This third-class Jeffers was named Onward No. 20. (Arthur Selleck.)

The rapid growth of the West Side and the location of P.T. Barnum's winter circus there led to the creation of a new firehouse and bell tower on Norman Street in 1887. Engine 3 was equipped with an Amoskeag second-class steamer, drawn by two horses named Fred and Dan. A horse named Major drew the hose car. Truck 1 (behind the steamer) was added here in the 1890s.

Fire once again visited P.T. Barnum's circus at his winter quarters on November 20, 1887, and burned 26 hours. Ironically, the fire was nearby Engine 3's first run. A number of animals in the menagerie were killed. Among the hazards faced by firemen were a herd of stampeding elephants and a lion, which attacked after a hose was turned upon it. The firemen escaped, but the lion had to be killed later.

The old hosehouses of Fountain Company 3 on Main and Madison Streets and Americus Company 6 on Broad Street were sold in 1885 to raise funds for a fifth firehouse. Engine 4 was opened in 1888 on Madison Avenue and George Street. This firehouse was the last to be built with a firebell tower.

Bridgeport received its first aerial ladder truck, a 75-foot Hayes, mounted on an American LaFrance, in 1892. The truck replaced the City of Bridgeport on Middle Street, becoming Truck 2. Engine House 3 on Norman Street put Truck 1 into service at this time, and probably used old City of Bridgeport No. 1 (which may explain the discrepancy in numbers) before receiving a similar Hayes–American LaFrance early in the 20th century.

Fireman Wilbur E. Judd of Steamer 2 gained the sad distinction of being the Bridgeport Fire Department's first line of duty fatality on June 26, 1894, shortly after falling off a 55-foot ladder. The fire burned at Wheeler and Howes four-story offices and warehouse at what is now Congress Avenue and Knowlton Street. The cause of the fire was labeled "spontaneous combustion." The building still stands today, directly across the river from the Bridgeport fire headquarters.

Some of the large factory complexes maintained their own fire brigades, such as Wheeler and Wilson, a sewing machine maker that was bought out by the better-known Singer in 1905. The firm maintained its own steamer and hose companies with more than 100 men. Some went on to become Bridgeport firefighters. This c. 1895 picture shows the Wheeler and Wilson firemen visiting the Warner Brothers fire brigade. Another industrial brigade at the time included the Pacific Iron Works.

Wheeler and Wilson's third-class steamer, named Seamstress, was one of only 31 steamers built by the J.B. Johnson Company. It also responded to fires in the neighborhood surrounding the plant. Singer later gave Seamstress to the Bridgeport Fire Department as a spare. It was retained long after the steamer era, first at Engine 5 (where it is pictured in 1938), and later at Engine 1. The only remaining Bridgeport steamer, Seamstress is preserved at the Connecticut Fire Museum.

After industrial and residential development flooded the East End, which had been annexed from Stratford in 1889 (the same year the town and city governments consolidated), Engine 6 was organized in an uncomfortable, rented firehouse on Seaview Avenue, c. 1895. The firehouse was very close to the New Haven railroad tracks; it was often complained that with all the noise accompanying an alarm, it was hard to hear the trains passing.

Capt. Henry Kampf sits in center of this c. 1902 portrait of the men of Engine 6. On the night of October 24, 1898, Captain Kampf barely escaped death when Steamer 6 was rammed at the Seaview Avenue railroad crossing by the New Haven Express. The captain jumped off the rear of the steamer seconds before it was struck. The train dragged the steamer almost one block to Central Avenue, killing the driver, the captain's brother John Kampf.

Four
NEW CENTURY, NEW IDEAS

Bridgeport entered the 20th century as a rapidly growing industrial city of almost 71,000 people—over 50,000 more than there had been 30 years before. The large numbers of factories and immigrants to work them led to increasing congestion and risks. A number of new neighborhoods were developed at this time. Commonplace were exciting scenes such as this one showing at least two Bridgeport steamers billowing steam as they feed hoses for a downtown fire.

Further growth on the West End prompted the establishment of Engine 7 at 575 Bostwick Avenue at the intersection of Pine Street in 1900. The firehouse was positioned so it could also cover Black Rock, which had been annexed from Fairfield with the West End (not to be confused with the West Side) in 1870.

The Locomobile factory was established in 1900 at the foot of Main Street. Known for its innovations in steam, gasoline, and electric automobiles, the plant was produced high-priced luxury automobiles. The plant also produced many of the Bridgeport Fire Department's earliest motorized vehicles. Locomobile was taken over by General Motor's founder William Durant in 1922 and folded several years later. (George Dragone.)

Engine 6 received a new firehouse on Barnum and Central Avenues, replacing the rented, ill-placed Seaview Avenue firehouse. Although the tracks had yet to be elevated, a bridge could carry the fire engines safely across the railroad tracks at Central Avenue, eliminating the danger that killed John Kampf in 1898. Completed in 1901, the station was occupied on January 22, 1902, under the command of Capt. Henry Kampf.

The new Engine House 6 served an area that was rapidly experiencing industrial, commercial, and residential growth. The East End received a major boast to its fire protection when Truck 3 was assigned to Engine House 6 several years after its opening. Note the twin chemical tanks between the third and fourth standing men. The use of chemicals to propel water was gaining increased favor in the Bridgeport Fire Department at the turn of the century.

A terrible conflagration tore through the heart of downtown Waterbury at 6:30 p.m. on February 2, 1902, consuming entire blocks of the business section. At 8:30 p.m., the Bridgeport Fire Department received a telegraphed plea for assistance. A special train was procured. Steamer 1, Hose Cart 4, and 13 men under Capt. Daniel Johnson were loaded on a railroad flatcar to assist those already there. (Mattatuck Museum.)

The Bridgeport contingent arrived in Waterbury at 12:26 a.m., joining Waterbury, Hartford, New Haven, Torrington, Naugatuck, and Watertown firefighters. The firemen were immediately put to work on Bank Street, which was in flames. The Bridgeport firemen were hand-picked from all companies and included Henry Kallman of Engine 4, pictured here in Waterbury on February 3, 1902.

At 3:30 a.m., word was received that the Scovill House hotel, where many refugees had been evacuated, was aflame. The ornate landmark was consumed by 50-foot-high flames in a matter of hours. Bridgeport firefighters hastened to the spot and put up a brave defense upon the next-door city hall's fire escape (right of Scovill) as snow started falling. The intense flames raged less than 15 feet from the firemen as workers evacuated vital material from the city hall. (Mattatuck Museum.)

The fire consumed 3 acres, including 32 buildings. Against all odds, Bridgeport firefighters saved Waterbury's city hall, prompting Mayor Kilduff to state, "I wish to particularly speak of the efficient work done by the Bridgeport fire company in saving the City Hall. Undoubtedly, if it had not been for their labors this building must have been destroyed No, I repeat, I cannot say enough in praise of these men." (Mattatuck Museum.)

Chief Edward Mooney (pictured at left) served as chief engineer (fire chief) from 1904 to 1915; he started his career with the old Excelsior volunteers. A stalwart champion of the chemical engine, Chief Mooney was a strong advocate of the interior attack, extinguishing the seat of a fire with the chemical's limited water supply before it spread throughout a structure. The fire department's new tactics, combined with Chief Mooney's aggressive fire investigations, virtually eliminated commercial arson for insurance fraud, which was rampant when he first took office. Half the department was comprised of callmen when Chief Mooney first took office, and he advocated and eventually received an "all permanent" force. He enforced a plan that broke up the old volunteer's Fireman's Benevolent Corporation, divided the proceeds equally among its members to settle a quarter-century dispute, and founded a contributory pension plan for the career firefighters. His 1934 obituary read, "Edward Mooney's personal friends loved him for his fine personal disposition, which he tried—unsuccessfully—to conceal under a gruff exterior."

Bridgeport's first true motorized fire engine was a Waterous pumping engine capable of producing 700 gallons per minute, assigned to Engine 2. Pictured here in a 1915 parade, the engine was purchased c. 1905; similar Waterous engines were added in later years. While old steamers were motorized, Engine 2 was the first to receive a fire engine designed and built from the start with a gasoline engine.

The 1906 Halloway chemical produced a stream of water when two tanks, containing soda water and acid, were mixed to produce a chemical reaction that forcefully propelled a limited supply of water from a hose. The advantage was a much quicker setup than a typical steam engine company. Drawn by two horses, the Halloway was the nucleus of the new Chemical 1 company, based with Engine 5 and Truck 2 on Middle Street.

Chief Mooney and his driver, Capt. Charles Holden, pose proudly in the chief's new Locomobile in 1907. Captain Holden drove the chief's horse-drawn carriage and had to learn how to drive an automobile when it changed. The carriage had been pulled by a white horse named Bobby; the sentimental chief had the Locomobile painted white in deference to the beloved horse that his car had forced into early retirement.

Rapid development prompted Chief Mooney to open two new firehouses in 1908. Engine House 8, pictured here, was located on the East End on Newfield Avenue near Beardsley Street in 1908. Of very similar construction, Engine House 9 was opened the same year on Lafayette Street between Gregory and Railroad Avenue in the South End. Both firehouses were two-bay, three-story buildings.

Chemical 1 received a motorized Locomobile fire engine on December 18, 1907, that carried 250 feet of hose and a 50-gallon soda-acid chemical tank. It was intended as a quick attack unit and as a "flying squadron" that carried additional manpower to fires. Virtually every alarm the company responded to in its early days resulted in complaints of the truck's high speed on city streets from residents who were still uncomfortable with motorized vehicles. This vehicle also responded to a number of requests for assistance in the towns of Stratford, Fairfield, and Trumbull over the years. When the Locomobile was replaced in 1929, retired Chief Mooney was quoted as saying, "She was a good friend, and never let us down. She has served Bridgeport as faithfully as possible for a machine to do, and has repaid many times over the care and work spent over her." Chemical 1 is seen being followed by motorized Truck 1 at the Municipal Parade on October 3, 1914.

In 1908, Truck 2 received one of the last horse-drawn fire engines ever purchased by the Bridgeport Fire Department. Another spring-loaded Hayes–American LaFrance, the truck received a motor-driven tractor only six years later. The 1892 truck was reassigned to Truck 1. New Truck 2 is seen practicing ladderwork on the Logan Building on Middle and Congress Streets, c. 1910. Note its three horses in the foreground. (Arthur Selleck.)

A two-alarm fire that began in a basement furnace of the Newfield Methodist Episcopal Church on Stratford and Central Avenues caused $25,000 damage the evening of Sunday, December 11, 1910. Fought in freezing weather, the blaze injured five firemen, who arrived on horse-drawn steamers and trucks or with the motorized "auto chemical" and Engine 2.

Traveling at 60 mph, the New Haven Railroad passenger train "Federal Express" jumped the tracks at a crossover switch just east of the Fairfield Avenue viaduct, smashing down a 20-foot embankment in the early morning hours of July 12, 1911. First arriving fire companies found themselves in the midst of a major disaster. The quick shutting off of electrical power averted a fire, but Bridgeport firemen would make many rescues from the tangled wreckage that terrible night. (Bridgeport Public Library.)

The "Federal Express" was carrying 22 players of the St. Louis Cardinals baseball team to a game in Boston. The team survived serious injury and some assisted in the rescue efforts. Many others were not as lucky. Fourteen people were killed, about 48 seriously injured, and 50 slightly injured. This picture is titled "Our firefighters lowering bodies from Federal Express wreck." (Bridgeport Public Library.)

Their useful lives not yet over, many old steamers traded their horses for gasoline-driven tractors. Engine 5, pictured here on Middle Street, received a tractor from Locomobile *c.* 1912, although the hose wagon remained horse-drawn for a couple of more years. Note the black bunting above the bay door, indicating a Bridgeport firefighter has died, though not necessarily on duty. The building next-door was the department's repair shop and blacksmith.

Engine 1 received a Nott motorized tractor in 1912, presenting an interesting contrast to Engine 5. The steamer, one of the last purchased by the Bridgeport Fire Department, was a 1906 Amoskeag Metropolitan First Class. Dogs would be kept as firehouse mascots in horse-drawn days. They would run ahead of the steamers, their bark acting as a warning much the same way as a modern siren. The unusual mascot for Engine 1 was a goat.

A new firehouse was opened for Chemical 2 on Maplewood Avenue in 1912. The new company ran briefly with the old Halloway horse-drawn chemical unit of Chemical 1 (pictured left of the firehouse), but received a motorized unit shortly thereafter. By this time, the fire department numbered 135 men. Chemical 3 was established on Barnum Avenue with Engine 6 and Truck 3 shortly thereafter.

Engine 10 began protecting the East Side from this firehouse at 268 Putnam Street in 1913. This firehouse was the last built for horses and steamers. It was also the last of four firehouses built under Chief Mooney's 11 years in office. At the end of the 20th century, it carries the distinction of being the oldest firehouse in service in Bridgeport, the last from the horse-drawn era.

The C.J. Cross Company of Newark, New Jersey, installed motorized tractors on Trucks 1 and 2 in 1914. Truck 2 is pictured in this period advertisement. Tractors extended the life of former horse-drawn apparatus for at least two more decades. It was noted that Engine House 3 was the first firehouse in Bridgeport to be completely motorized in 1914, along with 15 other fire engines—50 percent of the fleet.

Engine 2's Waterous pumper struck a raised manhole cover on the corner of Brooks and Putnam Streets in 1914, causing it to flip over onto its side. None of the firefighters were injured seriously, with the possible exception of their pride.

Engine 7 was one of the last fire companies to be fitted with motorized equipment. This caught the attention of the National Board of Fire Underwriters in 1915, when a study of the city urged that Engine 7 be motorized. This photograph of Engine 7 in front of their Bostwick Avenue firehouse was taken in 1916 as proof that the city had complied with the recommendations; the third-class American LaFrance steamer received a tractor. The steamer could pump 600 gallons per minute. Even though the steamers were motorized, Bridgeport engine companies continued to run with two fire vehicles—a "pump," which was the steamer or its replacement, and a tender or "hose wagon." Bridgeport was one of the last American fire departments to abolish the "dual engine companies," the last ones losing their hose wagons in 1992. Engine 7's hose wagon is a new Mack.

The fire headquarters on Middle Street is shown freshly renovated, having lost its Victorian "gingerbread" trimmings, c. 1917. The apparatus are now completely motorized. Truck 2 appears with its new C.J. Cross tractor (far right). Next, Chief Mooney's successor, Chief Daniel E. Johnson, was driven by Assistant Chief George Beardslee. George's father, Frederick Beardslee, was chief engineer from 1894 to 1896. To the right is Engine 5's new pumper, and beyond that is its Mack hose wagon. Standing in front of the car next to the hose wagon is Assistant Chief Al Mellor. Lastly, loaded with its flying squadron of manpower, is the 1907 Locomobile belonging to Chemical 1. The building beyond is the site of the department blacksmith, later called the maintenance division. Originally a place where the horses would replace their shoes, and steamers and wagons were repaired, the building remained the home of the maintenance division until 1927.

The hose wagons of Engine 4 (left) and Engine 7 are shown in front of Engine House 4 in this 1915 photograph. Both wagons are Macks, but notice that Hose 4 is equipped with a booster reel, while Hose 7 has a large volume "turret" gun mounted on top. Mack supplied a number of Bridgeport fire engines until American LaFrance took over in the 1920s.

This photograph was taken *c.* 1917 on the corner of Fairfield and Clinton Avenues. Entitled "Fire Laddies in the most modern equipment available," the picture shows Chemical 2 on the right and Chief Johnson's new car on the left. The commander of the team that assisted Waterbury in 1902, Chief Johnson served from 1915 to 1928. His car makes an interesting contrast to Chief Mooney's 1907 Locomobile

51

In 1916, the old firebells at Engine Houses 1, 2, 3, and 4, which had been used to summon the callmen, were sold as scrap. In addition to fires, the large bells were used for other purposes, such as alerting children that school was cancelled. Replaced in 1892, the bell of Engine 1 weighed 3.5 tons. The bell of Engine 2 fell as it was being removed, sinking 3 feet into the soft ground. This picture shows Engine House 3 with its bell tower.

Bridgeport's fire alarm system began in 1871, with 26 new Gamewell fire alarm boxes initially wired to the system. A telegraph alarm system was installed in 1903. Gongs inside the firehouses would ring out the box number, resulting in an "assignment" of fire companies responding. By the time this 1917 picture of the fire alarm system at the Middle Street headquarters was taken, the system had grown to over 270 fireboxes.

Five
Protecting the Industrial Capital

On November 11, 1918, after four years of war, the guns at last fell silent across western Europe. However, the streets were anything but silent after the news reached Bridgeport. This image shows the firefighters of Engine House 6 on Barnum Avenue with the West Side's Truck 1. They are celebrating with friends on that very first Armistice Day in a picture simply titled "Peace."

Sadly, the war did not end soon enough for Peter S. Pero of Truck 2. Born on June 19, 1889, he was appointed to the Bridgeport Fire Department on October 10, 1917. Only seven months later, he was called to military service on May 24, 1918. He was killed in action in France on September 29, 1918. A plaque was dedicated at the Middle Street headquarters in his honor; it was later moved to the new headquarters on Congress Street.

On December 31, 1918, "the fire department lost its most humble servants, in the horses, as the department was completely motorized on January 1, 1919." This ended an era that began when D.H. Sterling was put into service in 1864. Many firefighters of the era, such as Driver Henry Kallman, seen below with one of Engine 9's horses on Lafayette Street, grew very fond of them and marked their passing with some regret.

Truck 5 (With Eng-12) 55-ft Amer.LaFrance Service Truck-1917 #479

In 1917, the City built two combination municipal buildings—one in the sparsely populated Black Rock and the other in the North End. Engine 12 was based on the right side of this building on Beechmont Avenue and Thorme Street, while the Bridgeport Police Department's Fourth Precinct occupied the left wing. A similar structure housed Engine 11 and the Third Precinct on Fairfield Avenue. These were the first Bridgeport firehouses built specifically with motorized fire engines in mind.

Rather than assign Engines 11 and 12 a pumper and hose wagon, they were assigned one "triple combination" pumper that could pump water and carry enough hose to make room for "city service trucks." Truck 4 was assigned to Engine House 11, and Truck 5 to Engine House 12. As shown here, the city service trucks were manned by two firefighters and carried a truck company's full complement of ladders, minus the power-driven aerial.

55

Santa's elves had help from Bridgeport firefighters in the years around World War I. The rear of Engine House 3 on Norman Street was converted into a toy repair shop by big-hearted firefighters. The Bridgeport Fire Department has a long, honorable tradition of volunteering and supporting charitable and community organizations.

Box 317 was pulled at the corner of Congress and Middle Streets on December 9, 1920. Upon arrival, firefighters were confronted by a smoky fire in the Logan Building. Here, three firefighters steady a hose upon Truck 2's aerial, driving a stream into the fourth floor. Chemical 1 appears to the left of the ladder truck. Abandoned for years, the building's interior collapsed on August 2, 2000. It was razed that night.

Bridgeport firefighters hosted a minstrel show on February 4, 1921, at the Casino with Speidel's Full Orchestra in attendance. The purpose was to raise funds for the Bridgeport Firemen's Sick Benefit Society. The program read in large letters, "Owing to Short Space of Time Patrons Will Excuse Any Mistakes As It Is Our Duty to Put out Fires and Not Entertain People. Thank You." Of particular interest in the back row, third from left, is Assistant Chief Thomas Burns, who was later chief engineer from 1928 to 1940. To his right is Assistant Chief George Beardslee, whose father, Frederick Beardslee, was chief engineer from 1894 to 1896. Next to Assistant Chief Beardslee is Chief Engineer Daniel Johnson. The fourth man on the right, second row, is Ladderman William O'Malley of the chorus. O'Malley would rise to the rank of assistant chief; he died on November 11, 1947, a day after receiving severe burns at a factory fire. Fifth from left, first row, is the program's "interlocutor," Assistant Chief Alfred Mellor.

New American LaFrance spring-loaded aerials with wooden ladders were purchased in 1920, 1923, and 1925, completely replacing the old Hayes–American LaFrance trucks with their Cross tractors. Truck 3, pictured here, received the last one in 1925. The ladder could extend 75 feet. Thirteen years later, the truck was almost destroyed when a wall from the burning Barnum School fell on it, burying it under tons of bricks.

One of the worst fires of the decade occurred on October 21, 1927, at St. Mary's Roman Catholic Church. The church had been completed in 1877 on the corner of Pembroke and Steuben Streets. Possibly started in the furnace, the fire gutted the interior just one week shy of its 50th anniversary. Although the damage was extensive, the church was rebuilt. The church was razed and replaced in 1981.

A new firehouse was erected for Engine 2 behind its old one, facing Clarence Street. Dedicated on July 18, 1928, with a large block party, its first apparatus consisted of an American LaFrance 750-gallon-per-minute pumper and an old Locomobile hose wagon. Unlike many other firehouses, the new Engine House 2 had separate dorm rooms for the firefighters.

The old engine house that once housed the Protector No. 2 steamer continued service in the Bridgeport Fire Department. The department blacksmith and repair shop moved off Middle Street to the former firehouse. The maintenance division, or "shop," remained on Crescent Place until the 1990s. The drill tower at right was erected in 1947.

59

Thomas Burns became chief engineer of the department after Chief Johnson retired in 1928. On March 7, 1929, he summoned a rare general alarm for Box 328, the Frank Miller Lumber Company on East Washington Avenue. The fire took five hours to control in freezing weather. A crew led by Assistant Chief Beardslee became trapped on the second floor after a section of their hose failed. They held their position until the section was replaced.

More commonplace, even in an industrialized city like Bridgeport, were still alarms requiring only one unit. The men of Chemical 1 are pictured here with their old Locomobile, having just beat out a grass fire with brooms. The Hillside Volunteer Fire Department was formed in 1904 to combat brush fires in the North End. They ceased being active after Engine 12 opened, but their Main and Frenchtown Road firehouse remained a social club. They never owned apparatus.

After 21 years of service, the Chemical 1 Locomobile was placed in reserve in 1929. It was replaced by this 1928 Studebaker chassis, which contained soda-acid water tanks, along with a foam tank for oil fires that the maintenance division mounted. Chemical 1 is pictured here on April 30, 1938, during a fire at Box 32, the Reid and Todd Store on 1054 Main Street. Chemicals 2 and 3 received similar Studebakers.

The fire department was shocked on September 17, 1930, upon receiving the news that former Chief Engineer Johnson died of injuries six days after he was struck by a car at North and Laurel Avenues. He had retired only two years before. Under his leadership, the department moved into a two-platoon system in 1918, resulting in 52 new firefighters being hired and a better overall quality of life. Many openly mourned his passing.

On the night of January 11, 1932, fire swept the Brooks Sample Furniture Company in the former Masonic temple on 240 State Street at Broad Street. Burning upholstery produced toxic smoke that felled Chief Burns, Assistant Chiefs Beardslee and Mellor, and 54 other firefighters. A second alarm was pulled, and the remaining firefighters rallied around Assistant Chief Martin Hayden to extinguish the blaze as ambulances carried away the victims. All recovered. The corner is today's city hall annex. (Robert Novak.)

On December 31, 1932, Truck 2, a 1923 American LaFrance, responded to Box 34 on Broad and Cannon Streets and found the Union Light Company on fire. This picture was taken the following day. Firefighters and engines covered with ice is a scene repeated many times in Bridgeport, from the bucket brigade era to present day. (Arthur Selleck.)

The Great Depression was not kind to Bridgeport, as the city struggled in a continuous state of crisis to care for its newly unemployed. Many firefighters contributed as much as 10 percent of their wages to help the needy, even as the department budget was slashed. A decision by Mayor Buckingham to ask city employees to accept a 20 percent salary cut for the next two years led to angry protests that the employees should not have to shoulder the burden of the Depression. Chemicals 2 and 3 were eliminated c. 1933. Engine 9's Lafayette Street firehouse was also closed that year despite vigorous protests from South End residents. Engine Company 9 moved to Chemical 2's recently vacated Maplewood Avenue firehouse. The overall political chaos resulted in Socialist Jasper McLevy's election to mayor later in 1933. McLevy wound up serving 24 years, the longest in Bridgeport's history. He was forced to close Engine 8 in 1934, although federal funding arrived in time to prevent more closings. Pictured here c. 1910, Engine House 9 never reopened and was demolished in the 1960s.

The weather was not always kind to the Bridgeport Fire Department in the 1930s either. The Blizzard of 1934 not only paralyzed the city, but also managed to immobilize Truck 1 on a snow-covered city street. Here, firefighters dig to free the 1920 American-LaFrance 75-foot ladder truck from the snow's icy grip.

Truck 1 received the city's first new four-wheeled Mack tractor in 1937, the press touting how the vehicle left with four wheels and returned with six. Among the improvements were a windshield for the tillerman, an enclosed cab, electric windshield wipers, an electronic siren, air horns, and flashing red lights. Trucks 2 and 3 received Mack tractors later. This unique view comes from a photograph taken soon after the truck returned, with firemen training on the refurbished truck.

The Bridgeport Fire Department dedicated the nation's first Talkalarm system in the late spring of 1936. The system linked all firehouses, as well as the chief's house. Loudspeakers transmitted still and box alarms over a hard-wired system, which could be heard by everyone in the firehouse, instead of just the man on watch. Shown here is the "battery room," which housed the Talkalarm on the third floor of the Middle Street headquarters.

Chief Burns believed the "gongs" that alerted firefighters previously were detrimental to their nerves and hearts late at night. In this 1938 photograph, Ivan Onwin (standing) receives a box alarm on the old telegraph system in the battery room, while Edward Beyer (sitting) transmits the alarm over the Talkalarm. Firemen knew a box alarm was coming when they heard "standby for a Signal 29" over the speakers. Signal 29 was the police code for fires.

This interior view shows Engine House 7 on Bostwick and Pine Streets in the late 1930s. Firefighter "Span" Bowden is on the left. Perched atop the American LaFrance engine is station mascot Mooney, the cat. Mooney was named after Chief Edward Mooney, who died of natural causes on December 20, 1934. Reportedly, the cat's short and portly body reminded the men of their former chief.

In the previous image, Mooney the cat is perched this 1928 American LaFrance 750-gallon-per-minute pumper. The hose wagon behind the pumper was purchased in 1936; the fire department reverted back to purchasing Mack fire apparatus two years earlier. This hose wagon carried 1,250 feet of supply hose, plus 600 feet of hose to attack fires.

The upper floors of the three-and-one-half-story Barnum Public School caught fire on January 14, 1938. A stiff northwest wind fanned the flames on the west side of the building. Additional alarms were called. At the height of the fire, the center of the roof collapsed, causing the west wall to buckle, then tumble to the ground. The crews of Engine 2 and Truck 3 were showered by bricks. (Arthur Selleck.)

Capt. Walter Hopkins of Engine 2 was the most seriously injured, suffering two broken ribs. Two other firefighters from Engine 2 were injured as well. Truck 3 received the brunt of the collapse, the falling bricks practically destroyed its apparatus. Barnum School eventually reopened, minus its upper floors. The wreck of Truck 3 was sent to Mack Motors in Long Island City for a complete rebuild. (Arthur Selleck.)

BRIDGEPORT *knows* the value of Mack apparatus. Since 1934, this progressive New England city has purchased 14 Mack engines —8 pumpers, 3 hose wagons, and 3 ladder trucks. The latest of these is shown above.

Chief Thos. F. Burns of Bridgeport gives other fire chiefs this praise of Mack:

"Our continued yearly purchasing of Macks is based on their superior road and pumping ability plus greater stamina and better service."

Now is the time to modernize *your* department with Mack equipment!

MACK HAS THE FACILITIES TO BUILD THE FINEST IN FIRE APPARATUS — AND DOE

Mack once again began supplying Bridgeport with fire apparatus in 1934 and continued to do so until 1952. Originally numbered Truck 4, this city service truck was renumbered 11 before this Mack advertisement appeared in firehouses across the nation. Truck 4 on Black Rock's Fairfield Avenue replaced its old American LaFrance service truck in 1939, followed by Truck 5 the following year. Truck 4 carried 232 feet of ground ladders, as well as 150 gallons of water in a booster tank. The booster tank replaced the old chemical apparatus carried by the American LaFrance service trucks. Two firefighters continued to man the outfit; the company was called "engine and truck." Engine 11, behind the truck, was a 1938 Mack 600-gallon-per-minute pumper, which carried 100 gallons of water. By the end of World War II, every service ladder truck in Bridgeport was a Mack, and all aerials were pulled by Mack tractors.

The pictures on this page are among the first taken by Arthur Selleck of the National Board of Fire Underwriters, whose pictures appear throughout this book. This view shows a fire in Leavitt's Department Store at Box 32 at Main Street and Fairfield Avenue on April 30, 1938. Here, a curious downtown crowd mills about Engine 1 in the foreground on Fairfield Avenue.

Around the corner on Main Street, Art Selleck took another view of the fire from his father's office on the sixth floor of the security building. Engine 5 is at the bottom, with Truck 2 on the corner. Other fire apparatus can also be seen around Truck 2. The fire caused $6,332 in damage.

On January 25, 1939, a group of ice-skaters lit a campfire near Bunnell's Pond to keep warm from blustery weather at about 4:30 p.m. The wind caused the fire to spread to nearby brush, then to a five-story icehouse near the pond. The building was quickly incinerated, but burning tar from the roof was caught in the 40-mph winds, creating a firestorm over the adjacent neighborhood. (Arthur Selleck.)

The "Icehouse Fire" was one of the worst to strike Bridgeport in the 20th century. Three houses on Richardson (above and top) and two houses on Ashley Streets were destroyed, while many others on those, plus Hickory Street and Noble Avenue, were damaged by roof fires. Like the 1845 conflagration, residents of the Beardsley Park area piled belongings on the street, hoping their houses would be spared. (Arthur Selleck.)

Every available Bridgeport fire engine was called to the fire, with assistance from Nichols, Trumbull, Fairfield, Stratford, and Milford firefighters. Some apparatus, such as Engine 10's 1927 American LaFrance, pumped for 42 hours without a break. The fire went to a record seven alarms. Twenty-two were injured from burns, exposure, or both. Forty were homeless. Every off-duty firefighter and policeman was called in. The fires were only brought under control after the gale died down at 7:15 p.m.

A week later, a fire transmitted from Box 31 on Wall and Water Streets was photographed on February 1, 1939, by a *Bridgeport Times-Star* photographer. Truck 2 is pictured in the foreground. Note the two streams of water playing into the windows on the right. Ironically, the *Bridgeport Times-Star* later folded after a fire destroyed its Lafayette Street building on November 24, 1941.

71

Engine and Hosewagon 10 prepare to answer an alarm from its Putnam Street firehouse. Capt. Sidney Bray is in the left foreground. Edward Lynch is the driver and John Russo is on the hose wagon's rear step. The hose wagon was a 1920 Packard custom built by the maintenance division, while the engine behind is the same 1927 American La-France from the previous page. (Arthur Selleck.)

Arthur Selleck took this picture of Chemical 1 preparing to respond to an alarm from its Middle Street headquarters. Anthony Zakaskus prepares to drive, while Joe Cummings waits at the big wooden spring doors. All of the big doors were replaced by sliding garage doors by WWII. Chemical 1 responded to all boxes, as well as most still alarms; it was extremely busy.

Chief Thomas Burns surveys firefighters controlling a shed fire, c. 1938. A commissioner's meeting on July 23, 1940, saw the approval of General Order 266, which had all truck companies renumbered to correspond to the engine houses where they were stationed. Thus, Truck 1 became 3, Truck 2 became 5, Truck 3 became 6, Truck 4 became 11, and Truck 5 became 12. Chemical 1 became Chemical 5. (Arthur Selleck.)

The Bridgeport Board of Fire Commissioners authorized the purchase of a third city service ladder truck on March 12, 1940. Engine 10 lost its Packard hose wagon to make room for the new truck, which carried two firefighters. Designated Truck 10 under the new numbering system, the Mack served until 1971, at which time Truck 10 became a full strength ladder company. Trucks 11 and 12 were similar.

Tragedy hit the Bridgeport Fire Department on October 9, 1940. Chief Thomas Francis Burns responded to a tenement house fire on 300 Gregory Street at Park Avenue. He collapsed into the arms of Lt. Sylvester Jennings inside the smoke-filled structure after ordering a second alarm. He was rushed to Bridgeport Hospital, where he was pronounced dead. In this photograph, Acting Chief Martin Hayden and the department chaplain, Rev. James Killian, lead Chief Burns's funeral procession.

Mayor Jasper McLevy (left) and George Wellington, longtime fire commissioner, emerge from Chief Burns's funeral at St. Augustine's Cathedral on October 12, 1940. A number of firefighters broke down in tears when news came of the chief's fatal heart attack. Chief Burns was 66 years old, and had been a firefighter for 45 years. Martin Hayden served as acting chief until assuming the position permanently the following year.

Six
THE HAYDEN YEARS

Chief Martin Hayden, standing in front of his chief's car, was appointed a callman while employed at the Singer sewing machine plant on May 13, 1907, and was made permanent a year later. He became the effective chief of the Bridgeport Fire Department following Chief Burns's death, although he was not sworn in until January 6, 1941. Chief Hayden served until his death in 1952.

The crew of Truck 1 and Engine 3 stands in front of the Norman Street firehouse, c. 1940. Standing second from left is Capt. Percy M. Searles. Appointed on June 1, 1907, as a callman, he was made permanent in 1909. When he retired as an assistant chief on January 1, 1958, he had served for more than 50 years on active duty, a record only broken by Assistant Chief Arthur T. Platt, who retired in 1953 with 52 years of service. Platt served as acting chief engineer after Chief Hayden's death and before Chief Jennings was appointed to the post. Standing in the center of the picture, leaning against Engine 3's pumper, is John Gleason, who was Bridgeport's fire chief from 1971 to 1978, succeeding Chief Sylvester Jennings. Standing to the right of Gleason, Ferdinand Senger also retired as an assistant chief. The "old man" of the shift was Henry Kallman (standing partially visible at right). Kallman, a veteran of the Waterbury fire of 1902, retired not long after this picture was taken.

The entire shift of 21 men who compose Engine, Truck, and Chemical 5 poses in August 1941 inside their Middle Street quarters. Truck 5 serves as a backdrop. Capt. William O'Malley stands second from left in the second row; he became an assistant chief in 1944. Seven firefighters had already been drafted when the Japanese attacked Pearl Harbor on December 7, 1941. In all, over 40 firefighters would serve their country during the war, prompting the Bridgeport Board of Fire Commissioners to complain publicly in late 1942 that the draft was removing too many men essential to public safety. Rules such as wearing uniforms to work and night watches were relaxed due to wartime shortages, and the fire department actually had to hire men off the Civil Service's police department test to fill vacancies after all eligible men from the fire test were hired or drafted. All firehouses handed out small amounts of coal to the needy during the cold winter months after rationing created a shortage and trained for the possibility of an "Axis blitz" on Bridgeport.

David M. Howe Jr. was born on March 11, 1918. He was appointed on November 25, 1941, and assigned to Engine 5. He was granted a military leave of absence on February 10, 1942. Assigned to the U.S. Army's 3rd Division as a second lieutenant, he fought through North Africa and the Italian Campaign. He was awarded the Silver Star at Anzio, and his division received a Presidential Unit Citation for action in southern France in 1944. He was acting as captain and company commander of his unit at the time he was killed in action in France on October 2, 1944. Like Ladderman Peter S. Pero in WWI, Firefighter Howe had the sad distinction of being the only Bridgeport firefighter to die in combat during WWII. A plaque now hangs at the Congress Street fire headquarters in his memory.

Robert E. Halstead was born on December 7, 1915, appointed October 3, 1939, and assigned to Engine 2. Granted a military leave of absence on August 19, 1942, he joined the U.S. Navy, where he was assigned as a specialist third class aboard the fleet tug *Narragansett* (AT-88) of the U.S. Naval Salvage Force. He was in Palermo, Sicily, on August 23, 1943, when an air raid set two submarine chaser ships ablaze. Despite repeated air raids, he and others bravely fought the fires aboard the ships and were making headway when one of them was struck by another bomb. The resulting explosion killed a number of the dockside firefighters and destroyed both ships. In recognition of his valor, he was awarded the Navy and Marine Corps Medal, as well as a Bronze Star. He was honorably discharged from the navy, reinstated on October 15, 1945, and assigned to Truck 6.

A building of the Remington Arms plant on Helen Street and Boston Avenue was destroyed in an explosion that killed 7 and injured over 80. The blast sent flames hundreds of feet into the air, shattered windows for blocks, and set two nearby homes afire. Responding to Box 437, first arriving fire units like Truck 10, shown here, had to duck exploding bullets, which were flying into the street "like popcorn." (Arthur Selleck.)

Among those injured at the two-alarm Remington Arms explosion were ten firefighters, including Alex Bobalki (left) and George "Buddy" Clarke (center). Many thought an air raid was occurring and mobilized the civil defense units. Firefighters were and are no stranger to the Bridgeport Hospital emergency room. Appointed in 1938, Clarke was the city's first African American firefighter. Promoted to lieutenant in 1947, and serving as provisional captain at one point, he retired with commendation in 1968. Lt. Clarke passed away in 1978.

Chemical 5 received this Mack fire truck in 1942, and renamed it Squad 5. The old chemical equipment was replaced by a booster tank supplying the hose reel behind the cab. A similar Mack squad was purchased for the company in 1945. The 1942 vehicle was assigned to the short-lived Squad 6 at the Barnum Avenue firehouse. Squad 6 and the earlier Chemical 3 frequented the Pleasure Beach amusement park.

A two-alarm fire swept the A.W. Burritt Company at 360–540 Knowlton Street on February 28, 1943, spreading to a house on William Street. The fire was also fought with boats from the nearby Pequonnock River. The FBI was called to investigate after reports that a low-flying airplane dropped an object over the plant prior to the fire. Fears of industrial sabotage were high during the war, as many Bridgeport plants were defense related.

Truck 6 received the last of the new Mack four-wheeled tractors to pull its hook and ladder in 1943, at a time when the automobile industry was strictly regulated by federal agencies enforcing wartime deadlines and priorities. Notice the tractor's lack of chrome. All three of the American LaFrance spring-loaded, aerial ladder trucks from the 1920s received new Mack tractors between 1937 and 1943. (Peter Oliva.)

Anticipating new suburban housing in the North End and Upper East Side, the city built two new firehouses with federal funds in 1945; they were Engine House 14 on Sylvan Avenue and Engine House 15 on Evers Street (pictured here c. 1974). Many firefighters quit to take factory jobs in the mid-1940s, attracted by more pay and fewer hours, which led to a staff shortage that continued after the war and delayed the new firehouses' openings. (Arthur Selleck.)

Defying a city ordinance that forbade municipal employees from organizing, Bridgeport firefighters organized themselves into the city's first municipal labor union, Local 834 of the International Association of Firefighters, in 1945. In the notice sent to the fire commissioners, the charter members signed their names in a large circle because of concerns that the first person to sign would be seen as a labor agitator and would be dismissed. A series of public campaigns, such as the one illustrated, had reduced the number of working hours to the current 42 by 1957.

Leonard Kershner served as president of Local 834. He lobbied the Connecticut General Assembly to accept collective bargaining as well as a heart and hypertension bill supporting firefighters. He assisted other Connecticut fire unions with labor negotiations, continuing on a national level after becoming an IAFF staff representative after his 1971 retirement from the fire department. He died in 1974. Wood Avenue's new Station 3/4 was named in his honor.

Chief Hayden was able to secure a long-awaited training tower after arguing that new firefighters have less-experienced men to learn from because of the high turnover of the 1940s. The four-story brick and steel tower was opened on Crescent Place in the spring of 1947 near the machine shop. It was intended to assist in teaching ladder work, hose work, forcible entry, net jumping, and testing new equipment. (Lou Tibor.)

On November 10, 1947, Assistant Chief William O'Malley and his driver, John Horahan, were trapped on the second floor of the wood-framed Universal Sign Company (at 839 Railroad Avenue, next to this building) when leaking gas exploded, causing second- and third-degree burns. As O'Malley was wheeled into the ambulance, he asked if his other firefighters had escaped. He died the following day; his driver never returned to active duty. (Robert Novak.)

Chief Hayden and Capt. Jerome Barrett direct a two-alarm fire that destroyed the four-story New England Tobacco Company building on 855 East Main Street on January 19, 1948; it was the third two-alarm fire in 16 days. Note the soot around Chief Hayden's nose and mouth, the water on his rubber coat, the grime on his hands, and the fighting expression on his face. Firefighters of this era truly deserved the nickname "smoke eaters."

Experience gained in warfare began to show positive results in the fire service. In 1948, the press reported, "The most modern type of resuscitator inhalator and aspirator was purchased and placed on No. 5 Squad Wagon, to handle emergency cases due to drowning, asphyxiation, etc." Resuscitator calls, administering oxygen to patients, added even more runs to the already busy Squad 5.

The two brand-new empty Engine House 14 (pictured here *c.* 1947) and Engine House 15 were assailed by the press, who described them as "haunted" and "dust collectors." Thus, when a three-family house at 62–64 Edna Avenue was gutted by fire not far from Engine House 15 on February 2, 1947, public questions of manning and response times to the developing areas were raised. Squad 6 at the Barnum Avenue firehouse covered the Upper East Side temporarily, as new firefighters were hired and trained. Merging with Squad 6, Engine 15 was activated in its new firehouse in 1948. Engine 14 ran out of the Evers Street house before its Sylvan Avenue at Old Town Road firehouse opened later that year. Engine 14's location on the Trumbull town line was controversial, but it was positioned at the top of a hill, with roads leading away in all directions. The North End firehouse was closed during the 1992 fiscal crisis and converted into a police facility; Engine 15 is now covering this area from the Upper East Side. (Arthur Selleck.)

Bridgeport firefighters march in a late-1940s Memorial Day parade on Main Street. Holding the American flag is Alfred MacCalla, appointed in 1946, as Bridgeport's second African American firefighter. Reportedly, some questioned MacCalla as a flag bearer. However, the detail's captain silenced them by pointing out that MacCalla was a WWII veteran. He and George Clarke were the only minority firefighters until the 1970s.

As a result of increased hiring, better benefits, and fewer hours, the Bridgeport Fire Department had enough men to reactivate Engine House 8 on Newfield Avenue on April 1, 1949, under the command of Capt. William Flood (left, sitting). Note the hand crank on the old American LaFrance on the right. The firehouse closed for good after Engine 8 moved with Engine and Ladder 6 to Central Avenue in 1983; Engine 8 was deactivated in 1992. (Arthur Selleck.)

In part due to Assistant Chief O'Malley's fatal internal burns, Chief Hayden purchased 10 portable Chemox self-generating breathing masks in 1949, such as the one worn by the firefighter on the right holding the Geiger counter. Modeled after wartime gas masks, the packs provided a limited air supply and smoke filter for oxygen-deprived environments. The press dubbed the mask-wearing firemen "men from Mars." The purchase of two Scott portable oxygen masks and cylinders in 1952, like those worn by the firemen on the left, resulted in true self-contained breathing apparatus. Often rejected by the "smoke eaters" of the day, no Bridgeport firefighter now enters a burning structure without wearing the present-generation Scott mask, airpack, and cylinder. This picture was taken on November 23, 1958, while firefighters from Engine 2 demonstrated a "radiological firefighting team," at the training tower behind their firehouse, which was to combat "atomic emergencies" during the Cold War.

Chief Martin John Hayden was 70 years old and in his twelfth year as Bridgeport's fire chief when a fire broke out in an 85-year-old, 30-apartment tenement building at 146–162 Nichols Street in the early morning hours of December 6, 1952. Ever the aggressive leader, he quickly took command. Finding eight flats ablaze, he ascended to a second floor porch. While he was crossing a catwalk between two second-floor porches, the roof began to cave in. The catwalk gave way, plunging him 30 feet to the ground, where he was buried by debris. He was taken to Bridgeport Hospital by ambulance, where he was pronounced dead at 4:50 a.m. A sad footnote to this tragedy was Chief Hayden himself had condemned the building as a firetrap and unfit for human occupancy the previous February. Only six families, who were awaiting alternate housing, remained at the time of the fire.

The men of Engine and Ladder 6 salute Chief Hayden as his hearse passes the Barnum Avenue firehouse, draped in black bunting. Chief Hayden was the last of three chiefs who would be killed in the line of duty in a 12-year period and the last of three consecutive chief engineers who would die prematurely. The city joined the fire department in its shock, disbelief, and sadness.

Chief Martin John Hayden gets a final salute, as fire department pallbearers carry his coffin from his funeral at St. Charles Church to his final resting place. Assistant Chief Sylvester Jennings was appointed to succeed Chief Hayden on June 26, 1953. Chief Jennings held the position of inspector of combustibles, predecessor to today's Fire Marshal Division, which was organized in February 1950.

Seven
Signal 29, Signal 29

Bridgeport entered the 1950s with a population of more than 158,700 people. Twelve-term Mayor McLevy was defeated by Democrat Samuel Tedesco in 1957, on a platform of urban revitalization and renewal, by 161 votes. By then, Bridgeport was a city with an aging infrastructure, expanding suburbs in the North End, and a shrinking industrial base. Remembering its industrial past, the Bridgeport city seal includes a steamer fire engine at its lower left.

Sylvester Erle Jennings became a firefighter in 1919. He was appointed chief in 1953, replacing Interim Fire Chief Arthur T. Platt. The sometimes-embattled chief served until he was injured in the line of duty in 1967. He is seen here (right) in 1953, as Arthur Selleck of the National Fire Underwriters (center) inspects Engine 10 with Pumper Engineer Michael Iannotti. (Arthur Selleck.)

Firefighters responded to Box 621, the foot of Seaview Avenue, on June 6, 1953. The two-alarm blaze destroyed the prominent building at Pleasure Beach that housed a penny arcade. Originally called Steeplechase Island and later known as Pleasure Beach, it was opened in 1892 as Bridgeport's amusement park. Plagued by fires through its history, the city bought it in 1919. It deteriorated in the 1950s, and closed in 1960. A fire destroyed the Pleasure Beach Bridge in 1995, rendering the island inaccessible. (Arthur Selleck.)

Chief Jennings was blasted after he lit the Wordin Avenue dump on fire on December 17, 1955. "Burning off" excess garbage was not uncommon in the 1950s, and nearby Engine 7, nicknamed "the Dump Rats" because of their frequent runs there, was on its way to keep the fire controlled. The chief lit the fire before Engine 7's arrival, right after which the wind increased and changed direction, causing the fire to blaze out of control for several days. His primary critic, the "People's Newspaper" *Bridgeport Herald*, dubbed the chief's car, pictured here at the fire, "Nero's Chariot." Smoky and foul-smelling dump fires were major problems on the West Side, many of them burning for days, even weeks at a time. Firefighters recall reporting to work directly to burning garbage dumps. Defiant, though understandably embarrassed, Chief Jennings insisted the fire was lit as a safety precaution, to make room for holiday trash that would soon pile up.

Four American LaFrance tillers with hydraulic-raised, metal, aerial ladders were purchased between 1950 and 1957, replacing the old 1920s American LaFrances with 1940s with tractors. Truck 6, pictured here on the corner of Central Avenue and Grant Street, was one of them. From 1952 until 1971, all new fire apparatus were purchased from American LaFrance. Note the white Truck 6 placard on the cab door, covering the fact that the vehicle was originally assigned to Truck 5. (Lou Tibor.)

Truck 6 is pictured here at a fire on the roof of the old Locomobile factory at the foot of Main Street. The old building became the property of Remington Shaver. What was left of the once grand Locomobile factory complex was razed in 1965. Locomobile made some of America's best and most luxurious cars when automobiles were in their infancy and supplied the Bridgeport Fire Department as well. (Arthur Selleck.)

A three-alarm fire struck the A. Kleban and Sons toy and stationary store at 588 Water Street at Wall Street on the afternoon of February 27, 1957. An even larger fire struck the building in the winter of 1939. The fire burned for four hours, caused $500,000 damage and injured three people. (Arthur Selleck.)

A fire began in the second freight car in this picture, on a railroad siding only a foot away from First National Stores Grocery Warehouse on May 14, 1957. It quickly became a general alarm. A series of interconnected one-story wood buildings were burned, totaling 36,450 square feet. No less than two aerial and two ground master streams are operating in this picture, while a third aerial in the foreground prepares for action. (Arthur Selleck.)

Responding to a 1954 National Board of Fire Underwriters study that recommended a new firehouse in the northwest section of the city, Engine House 16 was opened in September 1957 on Madison Avenue near Geduldig Street. A truck company was originally intended to be based there, and a new American LaFrance 100-foot aerial was actually purchased for it, but a manpower shortage resulted in the new truck going to Truck 3. An 85-foot aerial ladder was stationed there and was briefly activated as Truck 16, but was mostly used as a spare. The huge station also boasted an open "comfort station" in the rear, for the convenience of persons visiting adjacent Ninety Acres Park, maintained by the parks department. Later considered grossly large for its lone engine company, the building was subdivided in the 1990s to include the maintenance department and other facilities, with a portion still allocated to Engine Company 16.

The flag is folded after being drawn for the last time at John Street firehouse of Engine 1 in March 1964. City officials and the press attended the final flag-lowering ceremony. The historic firehouse, home of the D.H. Sterling steamer, was in the way of an urban redevelopment project.

Engine 1's pumper and hose wagon leave their John Street firehouse for the last time. Their new home was the Middle Street headquarters. Engine 5 moved from Middle Street to Engine 4's quarters on lower Madison Avenue. Engine 4 was moved to Engine 9's firehouse on Maplewood Avenue. Engine 9 moved in with Engine 16 at the huge new firehouse on upper Madison Avenue. Nomadic Engine 9 was deactivated for good in 1967.

The old telegraph fire box system was replaced by a telephone-based system, provided by Southern New England Telephone Company. Here, an operator demonstrates the use of the new telephone boxes. The telephones connected directly with Bridgeport's Emergency Response System operators. The only telephone boxes left today are the ones in front of the firehouses.

The new telephone alarm system was activated on June 21, 1964. Leaving the Middle Street battery room, this new switchboard was constructed in the basement of the city hall. While the box numbers ceased to be called, the old "Signal 29" refrain was kept, as Bridgeport firefighters were already trained to listen for it. Operators continue to say "Signal 29" as a first alert before announcing box-alarm assignments.

The Middle Street headquarters appears here in April 1965. The demolition of the building across the street provided much needed parking to the area and made the firehouse visible from Main Street. The "new" Squad 5 is parked outside the front of the firehouse, while the recently demolished railroad viaduct can be seen behind the building to the left.

The new Squad 5 in the top photograph is pictured in this 1961 factory photograph, just before the vehicle's delivery to the Bridgeport Fire Department. Replacing the Mack, the 1961 Squad 5 was an American LaFrance with an overhead ladder rack, a 4-kilowatt generator, and a 300-gallon booster tank that supplied the reel containing 200 feet of 1-inch hose.

A pair of Bridgeport firefighters demonstrates Squad 5's new self-inflating rescue raft for launch at the old Beardsley Park beach in 1965. The beach was later destroyed to make room for the Route 8/25 expressway. The Bridgeport Fire Department operates three rescue boats today; the city's harbormaster has a number of specialized boats for water emergencies as well.

Bridgeport firefighters have been responding to car accidents and car fires since the first Locomobiles hit the city streets in the opening years of the 20th century. Squad 5 began carrying the first specialized vehicle extrication equipment for trapped accident victims in 1975; other tools had to suffice before then. In this Frank DeCerbo photograph, Engine 12 responds to a rollover on Main Street in the 1960s.

A three-alarm fire destroyed the Jay James Camera Shop on 193 Fairfield Avenue and the Dewhirst building behind it on 60 Cannon Street on July 21, 1968. Sixty firefighters were injured in the eight-hour blaze and the adjacent vacant Howland's department store was damaged. Three turret pipes on the ground and two aerial streams from Trucks 3 and 6 pour water on the fire in this view. (Frank DeCerbo.)

Truck 11's city service truck was replaced by this 1970 aerial, shown at the maintenance shop, at which time it was made a full-strength, six-man truck company. One year later, Truck 10 received a similar vehicle and was also brought up to full strength. Nicknamed "Baby LaFrances," these were Bridgeport's first ladder trucks with rear-mounted aerials; they lacked a tiller. This truck was sold in 2000. (Lou Tibor.)

The first of four new fire stations consolidating eight old single-engine firehouses was opened on Ocean Terrace in 1970, after sitting idle for several years after completion. Engine and Truck 11 from Fairfield Avenue and Engine 7 from Bostwick Avenue moved to the new station, while the older firehouses were closed. The trend to close fire companies within the larger firehouses also began here, when Black Rock's Engine 11 was deactivated in April 1976, despite strenuous objections from residents and the union. Engine 5 was consolidated with Engine 1, Truck 5, and Squad 5 at the new Congress Street headquarters in 1976. Engine and Truck 6 consolidated with Engine 8 on Central Avenue in 1982, and Engine 8 was closed in 1992. Engine and Truck 3 moved into new quarters with Engine 4 about 1985, and Truck 3 was closed in 1995. "Truck" companies were redesignated "ladder" companies in the 1990s. Squad 5 became Rescue 5 at that time. (Robert Novak.)

Eight
THE PHOTOGRAPHY OF JOSEPH LAMB

Both a fire and photography buff, Joseph Lamb began taking mostly black-and-white pictures of the Bridgeport fire department in action in the late 1950s, continuing into the early 1970s. Hundreds of pictures were taken, and his photographs often served as backdrops for storefronts. Above, the Henry C. Reid Jewelers on Broad Street promotes Fire Prevention Week, c. 1965, using some of Lamb's photographs.

The Bridgeport Firefighters' Historical Society is very fortunate to have a large number of Lamb's photographs. Among the earliest is a picture of a fire at Bridgeport Brass along the Pequonnock River waterfront in April 1957. The bridge on the right is the Grand Street Bridge, constructed in 1919 and dismantled in 1999. Incorporated in 1865, the sprawling Bridgeport Brass plant closed in 1980.

Back to the dump, yet again, for Engine 7's "Dump Rats." Firefighters open up with the turret gun on Engine 7's hose wagon, as burning debris sends a column of smoke high above Bridgeport. The long-burning, high-profile dump fires and their putrid smoke led to frequent complaints by residents, contributing to the dump's eventual closing.

Part of a firefighter's task, besides fighting fires and saving lives, is to maintain the firehouse, apparatus, and equipment. "Housework" is a daily chore in Bridgeport firehouses. Joseph Lamb captures a firefighter from Engine House 2 washing the windows of the apparatus bay. For many years the city's busiest engine, the company was deactivated in 1989, and its firehouse was turned over to the police department.

Firefighters buy, prepare, and cook their meals in the firehouses, both then and now. A good firehouse cook is much prized by members of his company. Here, such a cook in the kitchen of Engine 2 prepares hamburger patties.

The wooden Pleasure Beach Bridge periodically caught fire, as is shown in this Lamb photograph taken on June 17, 1965. Note the hose lines stretching to a private boat at left and a firefighter wearing a life jacket in the water (center). Today, both the Bridgeport Fire Department and the harbormaster are equipped with fireboats that can pump seawater into fires such as these. A later fire at this bridge in 1967 caused Chief Jennings to fall, severely injuring his hip. He never returned to active duty, undergoing surgery five times before formally retiring after 52 years of service in 1971. He was succeeded by John F. Gleason, who served until 1978. Retired Fire Chief Sylvester Erle Jennings died in June 1978 at the age of 84. Chief Jennings was the last fire chief in the 20th century to serve more than ten years. Still another fire caused the bridge to be condemned on Father's Day 1995, isolating Pleasure Beach Island from the rest of Bridgeport.

Similarly, the wood rail ties and platforms of Bridgeport's train station also caught fire periodically, as Lamb captures in this October 7, 1966 photograph. Note the engine company spraying water on the rails at right, while a truck company uses tall pike poles to expose the fire behind the platform's eaves. Bridgeport's beautiful 1900 Romanesque railroad station was closed after a new one was built in 1975. It was completely destroyed by fire on March 20, 1979.

Bridgeport experienced a drastic rise in arson fires from the late 1960s to the early 1990s. Here, a house on the corner of Myrtle and South Avenues burns fiercely on January 1, 1966, by the Entrance 27 ramp to the Connecticut Turnpike. Opened in 1957, the Connecticut Turnpike ran through some of Bridgeport's oldest industrial areas and neighborhoods.

107

The pumper engineer of Engine 5's American LaFrance appears to gaze longingly at the car passing with the dry interior as he awaits his crew's return on Lincoln Avenue and Lincoln Boulevard during a rainstorm in February 1966. Shop cabs were installed on the convertible fire engines by the maintenance division in the 1970s, and all new apparatus are now completely enclosed.

The crew of Engine 5 is faring little better, although their rubber boots are at least keeping their feet dry on submerged Lincoln Avenue and Lincoln Boulevard. Being a coastal city, Bridgeport is susceptible to flooding, particularly along the shoreline and under the railroad viaducts. Violent storms and hurricanes have also been known to raise havoc, the worst being the Great New England Hurricane of September 21, 1938.

Covered in ice, a firefighter flashes a smile at Lamb's camera on February 7, 1966. The fire was at the Peerless Aluminum Company on Andover Street. Water often freezes when it makes contact with a low-temperature surface, such as a firefighter who has been outside for hours. Hoses have been frozen solid and ladders stuck in up position from this problem. Truck 11's city service truck is behind him.

Snow did not make the job any easier. First arriving companies at a fire at Acme Shear on the corner of Arctic and Knowlton Streets rush into position as a wet, heavy, snowfall blankets Bridgeport on March 22, 1966. Now closed, Acme Shear manufactured scissors, both household and surgical.

Engine 16 responded to a still alarm at Ninety Acres Park on November 2, 1966, and found a large, century-old, hollowed-out tree burning on park property. After hosing down the interior of the tree, the hoseman and one other firefighter managed to prove the fire was out (and ham it up for Lamb's camera) by climbing inside.

Alfred MacCalla supplies a hose line to other firefighters working on an upper floor in this 1960s picture. MacCalla retired in 1974, as a pumper engineer, leaving the fire department without a single minority until several were hired in 1977. Federal Judge T.F. Daly ordered the department to hire 84 African American and Hispanic firefighters in 1978, after ruling a 1975 test was biased against minorities.

Bridgeport firefighters extinguish a smoky blaze in a Main Street storefront on March 3, 1965. Note that only three firemen, probably from Squad 5, are wearing Scott airpacks. With the arrival of plastics and other synthetic materials, smoke became more toxic in both the short and the long term. A number of firefighters from this era later developed respiratory problems. For this reason, airpacks are now required of all firefighters at structure fires.

Fr. Edward Doyle of St. Charles Church on East Main Street was the Bridgeport Fire Department chaplain when fire destroyed a block of stores at Gladstien Hardware and Watson's Department Store, just south of his church, on March 18, 1967. Over the years, the fire department has been fortunate to have a number of active chaplains (both Catholic and Protestant) appointed by the bishop. They administer aid and comfort to firefighters and victims, and, if necessary, administer the last rights.

Shown the morning after the fire of July 22, 1968, are the Jay James Camera Shop and Dewhirst Building on Fairfield Avenue and Cannon Street. This picture captures some of the same units visible in Frank DeCerbo's photograph (see page 101), only at ground level. Note the "turret gun" in the foreground left and the firefighter repacking equipment on Ladder 3 on the right. The charged hose (often called "spaghetti" by firemen) surrounds Engine 4's pumper and the hose wagon is being repacked behind the pumper (probably belonging to Engine Company 4). This is a typical scene after the excitement of a fire is over and the crowds have dispersed. The successful defense of the vacant Howland's department store from the raging flames led a grateful Mayor Hugh Curran to say to newsmen at the scene, "Now you see why I boast we have one of the best fire departments in New England and possibly in the country."

Four structure fires struck Bridgeport in two hours on the afternoon of January 23, 1968. A fire broke out at a four-family house on Huron Street at 12:54 p.m., only 13 minutes after a barn fire broke out in the North End. West Side fire companies rushed to the East Side at 1:34 p.m., when a third fire broke out at Pequonnock Foundry at 330 Fifth Street. At 2:06 p.m., a fourth fire was discovered at Art Metal Products at 230 Fifth Street. In this remarkable photograph, firefighters and civilians run to the fourth fire from the third fire moments after its discovery past hoses that are carrying water for the Pequonnock Foundry blaze past the burning Art Metal Products. Additional companies from all over the city scrambled to the scene, while neighbors assisted firefighters in stretching hoses from one Fifth Street fire to the next. Recall for both Fifth Street fires was declared at 2:29 p.m. All four fires were considered set, the ones on Fifth and Huron Streets possibly by the same arsonist.

113

Already targeted for demolition at the time of the 1968 Jay James fire, the Howland's department store lasted less than a year. On March 7 and June 10, 1969, fires gutted the six-story landmark at Main Street and Fairfield Avenues, and the building was subsequently razed. The store had been closed since June 1965.

Civil Defense (CD) staged a mock disaster drill for eastern Fairfield County on April 27, 1969, simulating an airplane crashing into Ninety Acres Park. First arriving units, such as Engine 16 pictured here, found actors and actresses with very realistic makeup simulating dead and injured victims on the ground and even dangling in trees. The CD ruled the drill a success in gauging local emergency response to large-scale disasters like this.

Fire silhouettes a hose wagon operating a turret gun at a fire that destroyed Breiner's Furniture on Fairfield Avenue, known to many as the old Ritz Ballroom, on the night of June 17, 1970. The most elegant dance hall in the city, the Ritz Ballroom opened in 1923. It hosted such names as Louis Armstrong, Tommy and Jimmy Dorsey, Artie Shaw, Rudy Vallee, and Guy Lombardo. It closed in 1961.

Firefighters advance two hose lines into the Rapids Furniture Company on State Street in August 1970. Meanwhile, a truck company or Squad 5 begins to break down a front door with an ax on the left. Note the ground ladder, on the left, and a third line in the narrow alleyway, on the right. Bridgeport firefighters continue Chief Mooney's tradition of rapid, aggressive attack started at the beginning of the 20th century.

Water cascading from a second-floor fire escape seems to fall unnoticed by all except for cameraman Joseph Lamb. Both this building and a three-story tenement next-door were gutted by fire on the corner of State Street and Colorado Avenue on February 24, 1973. Firemen are just beginning to advance into the burned-out shells, after the aerials have shut off their elevated streams.

The late Joseph Lamb's photographs have succeeded in immortalizing the late 1950s through the early 1970s. Not only did he produce a substantial quantity of photographs, but he also followed the fire department in all kinds of weather. This Lamb photograph shows a fire that damaged three Water Street meat-packing companies during a snowstorm on December 27, 1969. Lamb captured nearly every facet of the era's firefighting in unposed, sometimes brutal honesty.

Nine
Postscript

The years following Sylvester Jennings's retirement were fraught with tumultuous changes, both in the city and within the department. This chapter highlights only a very small portion of that. It would take another book to cover this period adequately. This Lamb photograph shows what was to become a common scene on Bridgeport streets.

Squad 5 continued to carry oxygen for medical emergencies. However, its "resuscitator calls" declined as new oxygen tanks were purchased for additional companies. Today, all Bridgeport fire companies carry oxygen, as well as first aid kits, although engine companies cover the majority of the emergency medical calls. Since 1994, all new firefighters must become certified medical response technicians.

Ground was broken on June 26, 1974, for the new fire headquarters on Congress Street at Housatonic Avenue, on a site occupied by a United Illuminating substation and near the ancient Pacific Iron Works many years before that. The new headquarters replaced the original Middle Street headquarters, built in 1876. The old Middle Street headquarters was razed in 1989 to make room for the widening of Water Street behind it.

The new $4 million, state-of-the-art, split-level fire headquarters was dedicated at 30 Congress Street on October 16, 1976. The firehouse was built along the Pequonnock River, directly across from the still standing building that claimed the life of Wilbur Judd, the city's first firefighter to die in the line of duty. The new facility housed the apparatus and crews of Engine 1; Engine, Truck, and Squad 5; and the West Side Assistant Chief in "drive-through bays" that allow apparatus to exit either to Congress Street or Housatonic Avenue. The all-in-one building also housed the Arson Division, Fire Prevention, Plan Review, Training Division, Fire Department Administration, and all chiefs' offices. A meeting hall was also included for commissioners' meetings and other functions. The Emergency Response System moved from the basement of city hall to this facility. A boat launch was later added behind the fire station to allow quick access to Bridgeport Harbor and other waterways. Like Engine House 16, public bathrooms were originally added with outside entrances along the riverfront.

Also unveiled at the dedication of the new fire headquarters was the new lime-green 1976 Ward LaFrance Snorkel, which would soon become Truck 5. Embracing a concept pioneered by the Chicago Fire Department, the vehicle had an 85-foot "cherry picker" crane, with a basket that could hold firefighters on the end. Rather than expanding and retracting like a conventional aerial ladder, the snorkel had an adjustable hinge in the middle of it. Working in tandem, the basket, hinge, and turntable could do amazing things such as reaching over power lines. The snorkel was also the first aerial to feature a pre-piped waterway, now standard on all Bridgeport apparatus, which allowed for quicker setup of elevated water streams. Its odd armlike crane and basket soon became a familiar silhouette against flaming Bridgeport skies. The snorkel was later moved to Truck 11, where it served until the mid-1990s. Bridgeport firefighters tended either to love or hate this truck. Today, Truck 5 is equipped with a 1993 tower ladder. (Lou Tibor.)

Bridgeport purchased a total of six Ward LaFrance pumpers, starting with a foam unit for Engine 8 to cover the airport, from 1974 to 1975. They were nicknamed "yellow birds" by firefighters because of their most distinguishing feature; they were painted a very light yellowish green, following a nationwide trend to make fire engines more visible at night. All subsequent apparatus were lime-green until 1982. (Lou Tibor.)

Engine 10's old 1947 750-gallon-per-minute Mack pumper was replaced by a 1000-gallon-per-minute Ward LaFrance yellow bird in 1975. Operating as a spare for a while, the pumper was sold to the Bridgeport Area Retired Firefighters, where the vehicle was maintained. In 2000, the vehicle became property of the Bridgeport Firefighters' Historical Society, formed on May 20, 1997.

Although no firefighters are permanently assigned there, a firehouse is located at the Bridgeport Municipal Airport. Formerly known as Mollison Airport, Bridgeport purchased the airport in 1936 in the Lordship section of Stratford and continues to operate it today. Initially dubbed "Airport 17," this 1968 International Ansual was bought to combat aircraft emergencies, to be manned by either aircraft personnel or firefighters from nearby firehouses like Engine 8 or later Engine and Ladder 6.

Pictured here at the airport, a lime-green Ford Series 800 became the new Squad 5 in 1979. Nicknamed "the War Wagon," this vehicle saw perhaps more fires relative to its time in service than any other vehicle the company operated. Its body was completely rebuilt by Mack in 1984; its engine was replaced in 1988. It was replaced by the current Pierce rescue squad in 1992. (Lou Tibor.)

The city purchased six Mack CF 600 series 1500-gallon-per-minute pumpers in 1982. The first red fire apparatus the city purchased in over a decade, one assigned to Engine 15 is currently the oldest pumper serving in the Bridgeport Fire Department. The year 2000 finds three others in reserve, another sold to the Fairfield Fire Department, and one recently discarded. Ladder 11's 1977 Seagrave is currently the oldest truck. (Lou Tibor.)

Their silhouettes surrounded by flames, a pair of firefighters train water on three apartment houses that burned the night of June 16, 1980. Ironically, the same site would become the location of the new Engine House 6/8 in 1982. Unfortunately, it was only discovered after the $2.3 million firehouse was built that the property had never been formally sold to the city. The matter was resolved years later.

Truck 12 retained its 1939 Mack city service truck long after the other, similar trucks were replaced by aerials. Of the three city service companies, Truck 12 was the only one never made into a full-strength ladder company. The Mack was retired in the mid-1980s; the North End's Truck 12 was closed as a union concession in 1991.

Trucks 3 and 6 received new retrofitted tractors from American LaFrance in 1980 and 1982, respectively, extending the service lives of these tiller-drawn aerials considerably. Truck 3 was assigned the 1970 "baby LaFrance" after Truck 12 was closed in 1991. Surviving long enough to be redesignated Ladder 6, the city's last tiller-drawn ladder truck worked until it was replaced by a 105-foot Pierce aerial in 1994. (Lou Tibor.)

Along with Engine 6, Engine 10 was the last company to lose its horses in 1918. Now slated for replacement, the Putnam Street quarters of Engine and Ladder 10 is now the only firehouse remaining in active service from the horse-drawn era. Appearing deceptively small for the large, modern apparatus it contains, the firehouse's equipment is anything but old fashioned. It is interesting to note that the 1993 Pierce 1250-gallon-per-minute engine (right) is the last in the city that dries its hose on a 50-foot-long hose rack, the same way the company's horse-drawn predecessors did in 1913. Ladder 10's large 105-foot Pierce aerial (left) is equipped with automated "all-wheel steering," which duplicates some of the functions of the old tiller-drawn trucks and makes it necessary to make the tight turn onto Putnam Street. (Robert Novak.)

Chief Gerdineir appears above. Listed below are the chiefs of the Bridgeport Fire Department (with year of appointment) since the career department began in 1872.

Charles A. Gerdineir	1869
Frederick P. Beardslee	1894
William H. Coffin	1896
Edward Mooney	1904
Daniel E. Johnson	1915
Thomas F. Burns	1928
Martin J. Hayden	1941
Arthur T. Platt	1952
Sylvester E. Jennings	1953
John F. Gleason	1971
Bernard P. Finn	1978
John A. Schmidlin	1980
John T. Moran	1989
Thomas R. Naples	1990
Gerald F. Grover	1991
David Schiller	1996
Michael Maglione	1997

A number of Bridgeport's firefighters have made the supreme sacrifice in protecting citizens from the ravages of fire over the years. The Bridgeport Firefighters' Historical Society is currently researching all line-of-duty fatalities. Our current list of fire fatalities includes the following:

Firefighter Wilbur E. Judd	June 26, 1894
Pumper Engineer John Kampf	October 24, 1898
Chief Thomas Burns	October 9, 1940
Captain John W. Doolan	April 26, 1942
Assistant Chief Thomas J. O'Leary	April 3, 1944
Firefighter Clarence F. Beardslee	December 30, 1945
Assistant Chief William C. O'Malley	November 11, 1947
Chief Martin Hayden	December 6, 1952
Lt. Henry R. Lattanzi	November 19, 1971
Firefighter William V. Keogh	April 19, 1973
Firefighter Nicholas T. Auriemma	November 9, 1978
Captain Francis D. Federici	March 3, 1982
Captain Albert F. McGovern	March 21, 1983
Lt. William M. Hathaway Sr.	November 11, 1986
Firefighter Walter J. Flyntz	March 17, 1999

The last fire fatality of the 1900s was 44-year-old Walter Flyntz of Engine 3, who died of a heart attack at a structure fire. His funeral hearse and Engine 3 are shown in the photograph above in front of St. Patrick's church on March 22, 1999. (Lou Tibor.)

Today, the Bridgeport Fire Department protects its city and its inhabitants with a culturally diverse force of more than 390 men and women. Operational strength at the close of the 20th century is ten engine companies, four ladder companies, and one rescue company divided between eight firehouses in two battalions. Although the wording has changed, the mission statement of the Bridgeport Fire Department remains the same as it always has been: "We, the members of the Bridgeport Fire Department, are dedicated to serve the people of the City of Bridgeport. We will safely provide the highest level of professional response to fire, medical, environmental emergencies and disasters, either natural or manmade. We will create a safer community through our extensive participation in Fire Prevention, Code Enforcement, and Education for the public and department members." The history of the Bridgeport Fire Department is written every day, every time a company responds to an alarm or detail. This photograph shows Firefighter Tim Gies, a Gold Star recipient in 2000. (Glenn Duda.)